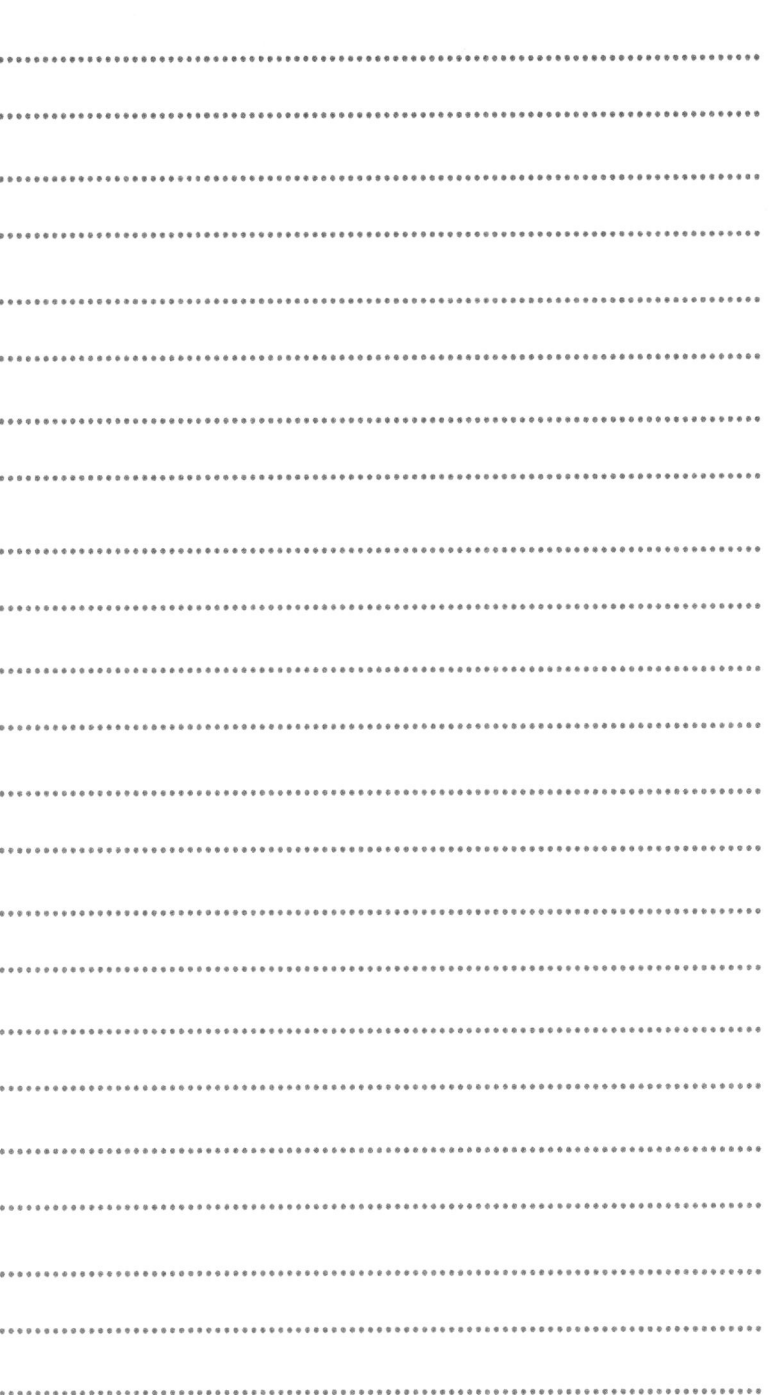

THE MORE
YOU PRAISE AND CELEBRATE
YOUR LIFE, THE MORE
THERE IS IN LIFE
TO CELEBRATE.

................OPRAH WINFREY.................

www.ingramcontent.com/pod-product-compliance
Lightning Source LLC
Chambersburg PA
CBHW071838200526
45169CB00020B/1863